WHY FLYING FISH DON'T FLY HIGH IN THE SKY

AN ANCIENT HAWAIIAN TALE

A Picture Book and
Coloring Book combined!

by

Stephen E Jorgensen

Published by

CyberSuccess Publishing
Honolulu, Hawaii

Illustrated by author

Stephen E Jorgensen

ISBN-13: 978-1979913676

ISBN-10: 1979913676

copyright © Stephen E Jorgensen 2017

WHY FLYING FISH DON'T FLY HIGH IN THE SKY

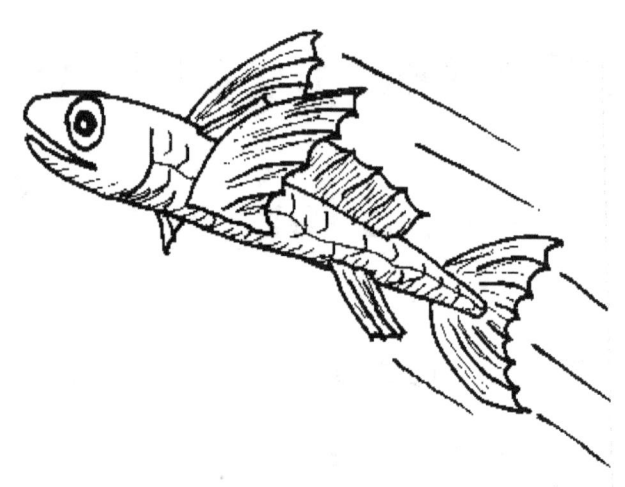

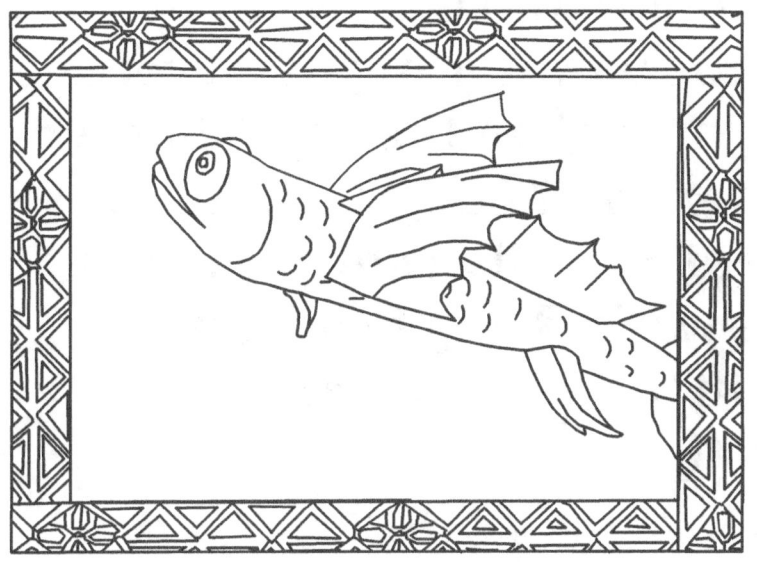

Kalani the flying fish

Kalani means Means "the heavens" it is from Hawaiian where ka ="the" and lani = "heaven, sky, royal, majesty".

Flying fish can really fly, not just jump out of the water, but fly over the waves. But you never see them fly high in the sky. You ever wonder why? Long ago , so the ancient Hawaiian story goes, there was a flying fish who flew high in the sky, up where the birds fly.

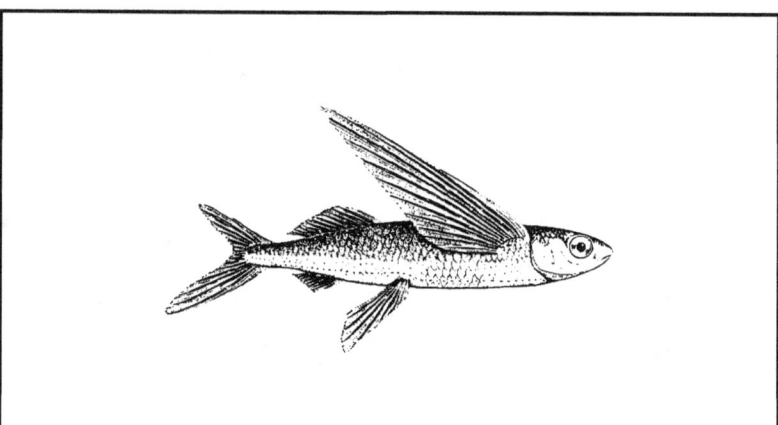

Pacific Flying Fish. Range 160 feet, height of flight, 10 feet.

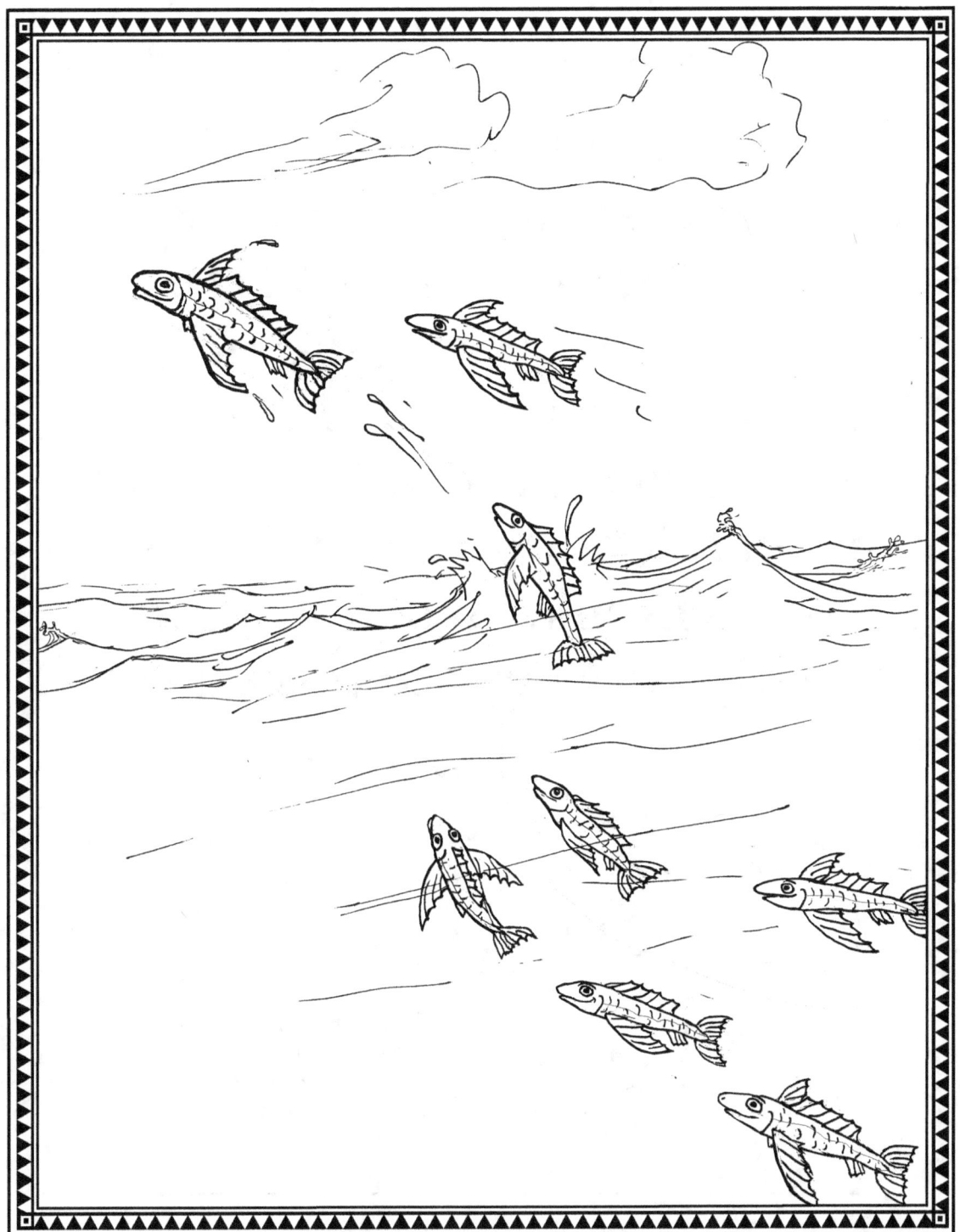

His name was Kalani, and for the longest time he was just like all the normal fish. He swam in the ocean and played with all his many brothers and sisters, and all their fishy friends. They swam in large fishy schools, all swimming together. Always together.

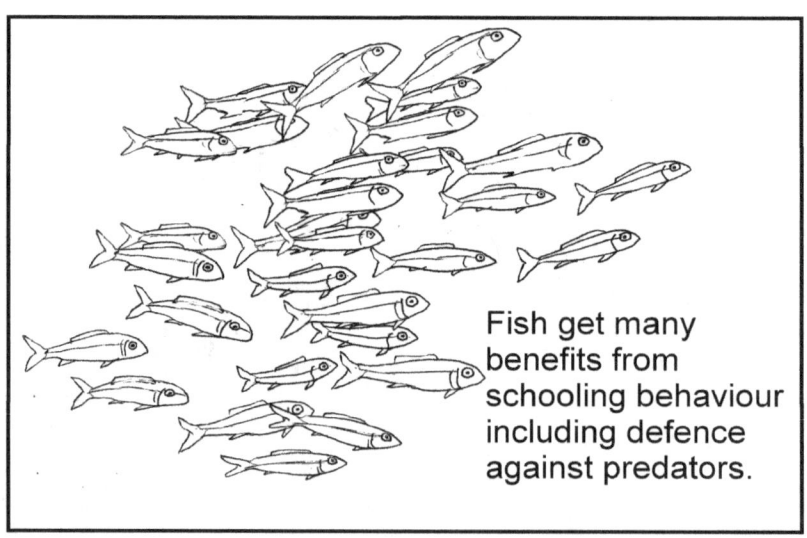

Fish get many benefits from schooling behaviour including defence against predators.

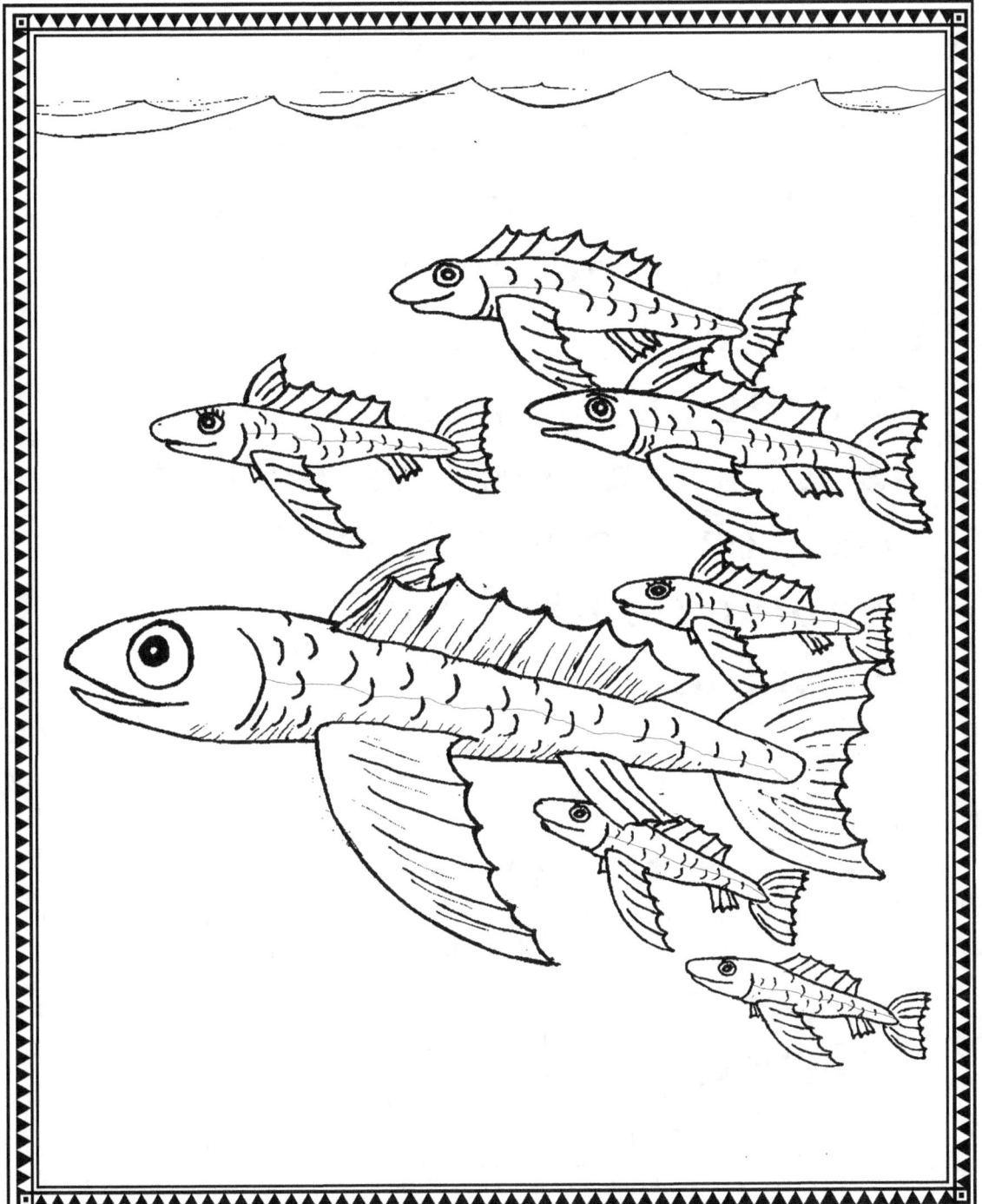

They were always laughing and playing in a group, and often they would burst from the water and skim right over the tops of the waves. And then they would plunge back into the cool water and chase each other down into the blue depths. It was so much fun.

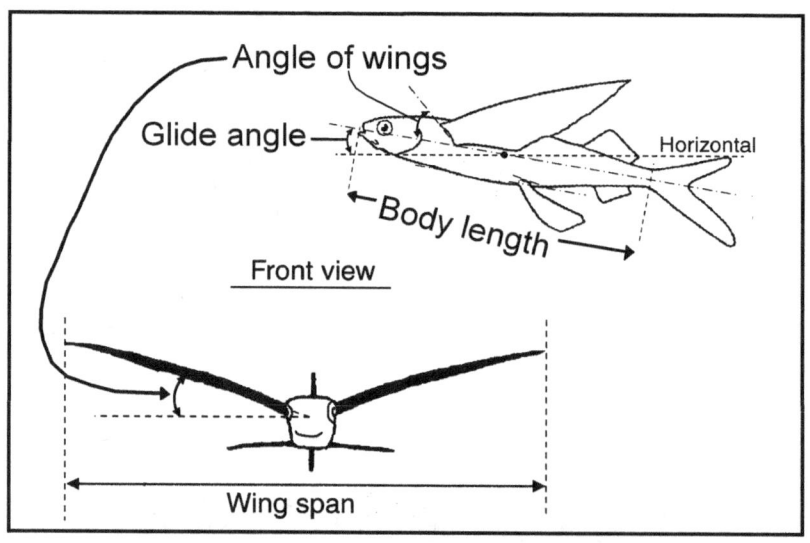

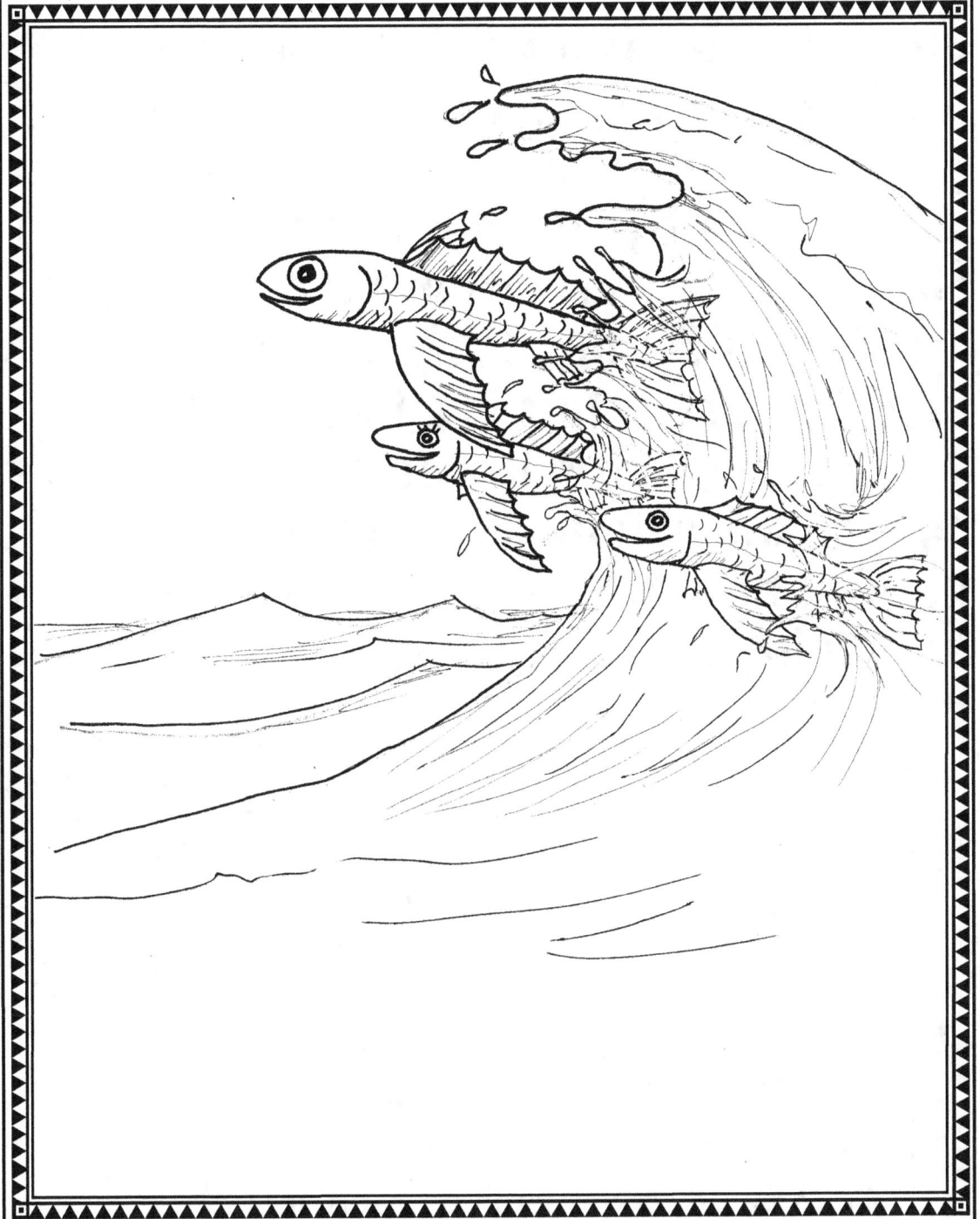

But sometimes Kalani would see the birds fly by, so high in the sky, and he would wonder why. Why couldn't he fly so high like those birds in the sky? When he asked his friends family, they always said, "No, no, that is a bad idea, flying fish belong in the sea, not high in the sky like the birds flying by. Kalani would sigh, and go back to playing in the blue waves.

Birds can fly together in a group, it is called a flock of birds.

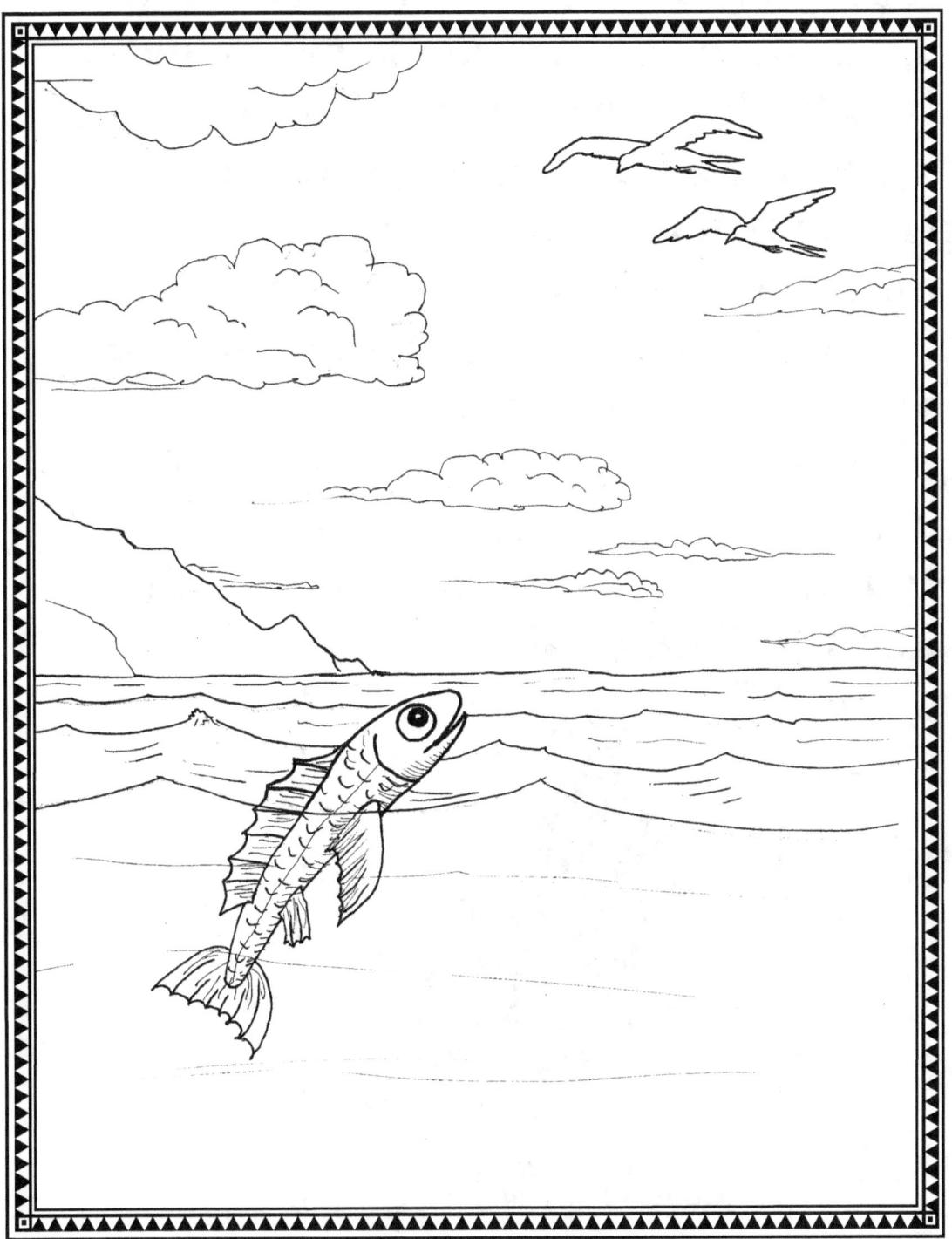

But one day, he decided to give it a try, to fly high in the sky. So he swam extra fast to build up some extra speed then and bursting out of a wave, he zoomed up into the sky so high. At first it seemed so fun, flying in the sun. He zoomed right up to where a bird was flying by. The bird was startled and squawked "Craw, craw!" (He was a Hawaiian crow, an Alala). "What are you doing here?" the flustered crow asked the flying fish.

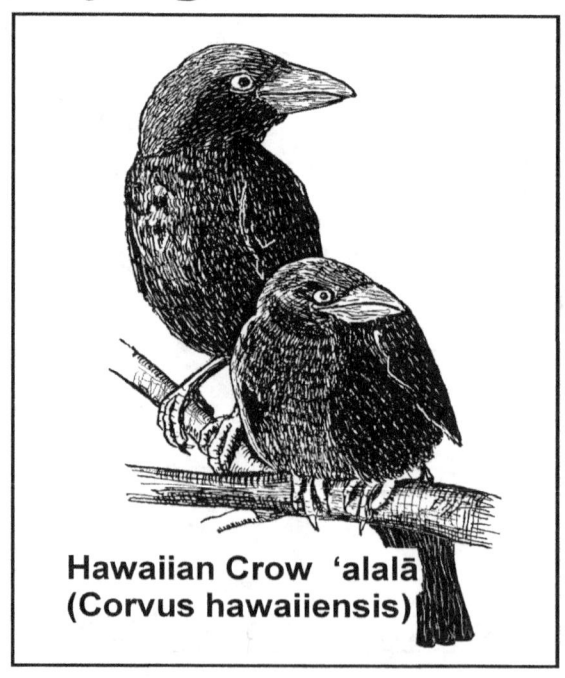

Hawaiian Crow ʻalalā
(Corvus hawaiiensis)

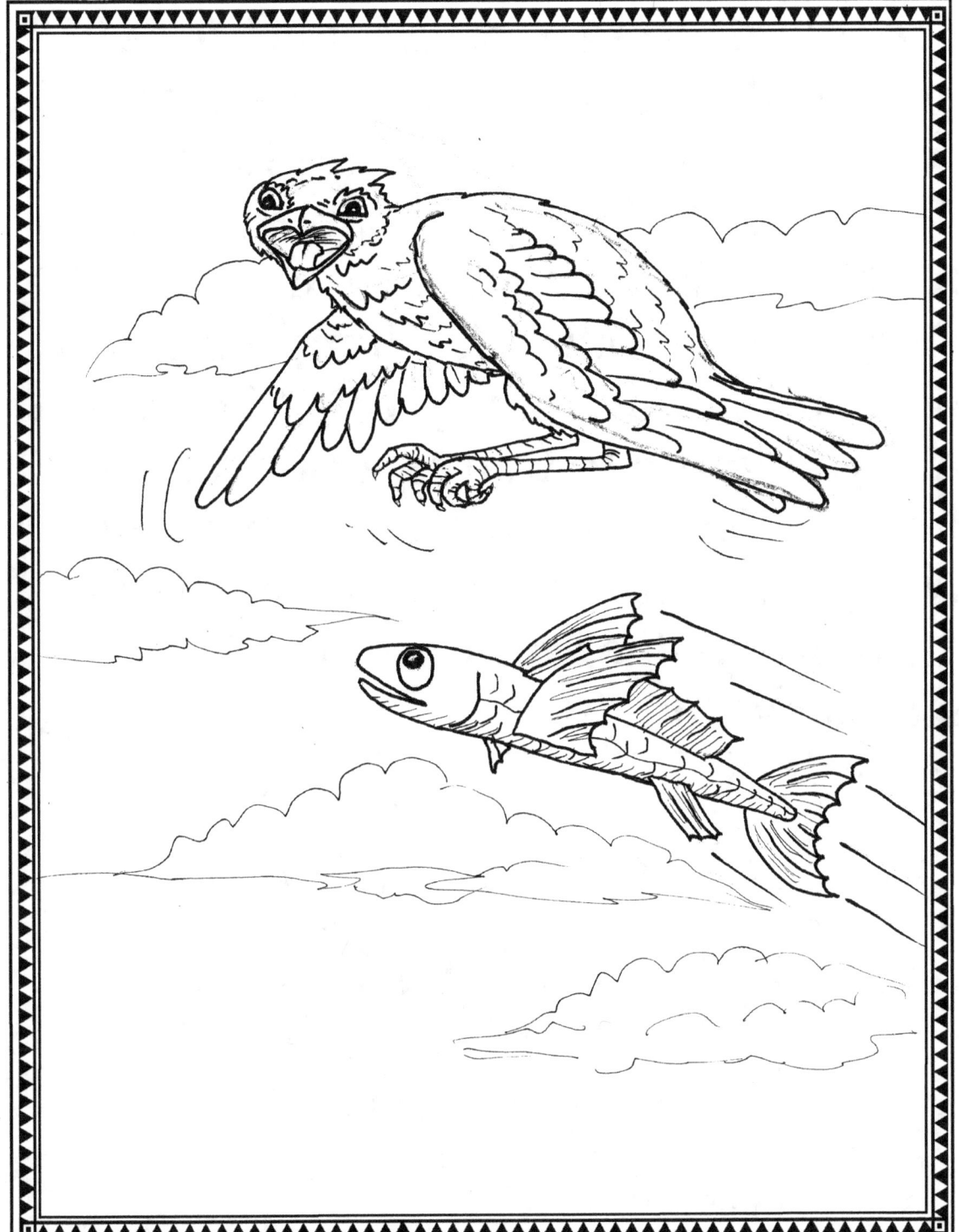

"I'm flying along just like you." Kalani answered. "I can see that." the crow said, "But why?" "Well," said Kalani, "I always wanted to fly high in the sky." But he was having a hard time. A fish's wings are not made for flapping like a bird. "Where are you going?" he asked. "Are you going to that island over there?" "Yes." the bird answered. "I'm flying home, hopefully to a nice fish - ah, a nice dish of supper. Do you want to come along?"

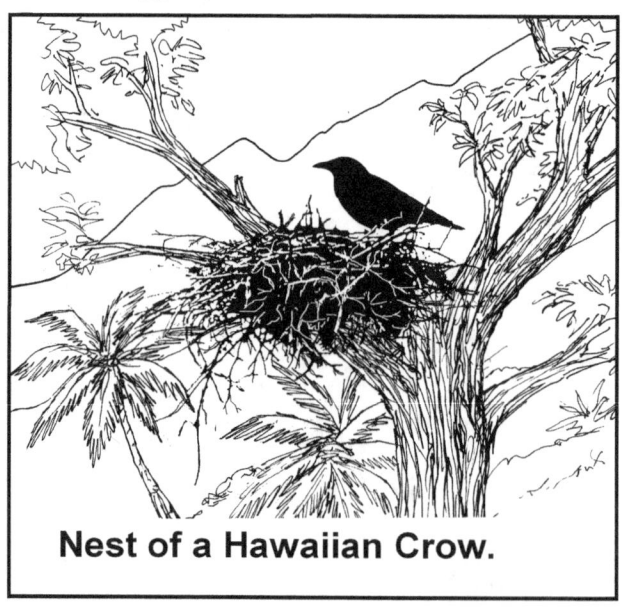

Nest of a Hawaiian Crow.

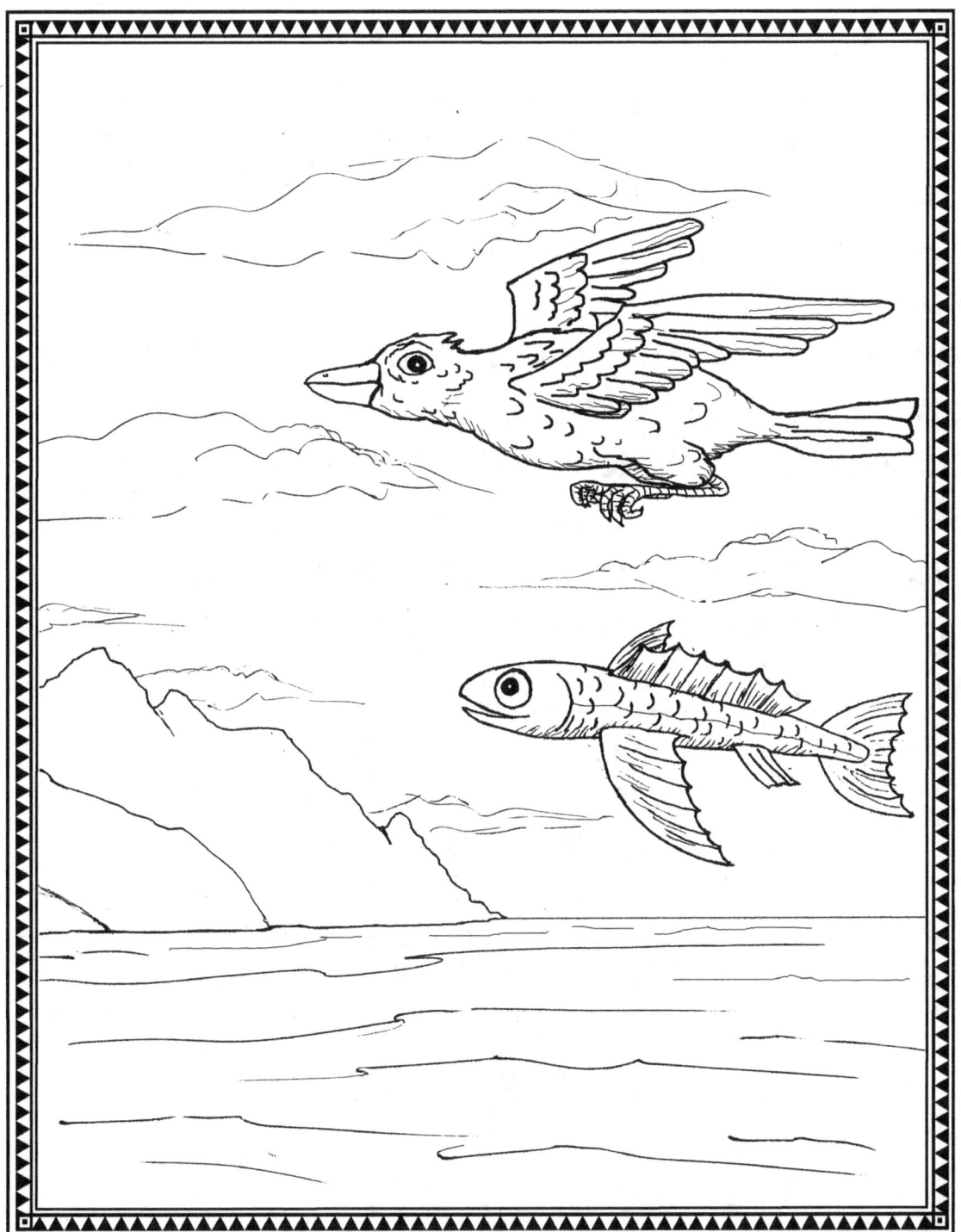

"No." said Kalani, panting a bit. "I'm getting tired. It is so hot and dry up here, I think I will just dive down to the ocean where it is so cool and wet." "No you don't." said the bird and he grabbed Kalani with his claws. "You're coming home with me to be my supper." "No. No!" yelled Kalani. He struggled to get free, but the hot air so high above the above the waves had dried out his skin and scales and he was no longer slippery like a fish should be and instead was all dry. He struggled and wriggled, but he just couldn't free himself from the crow's grip. The crow flew on.

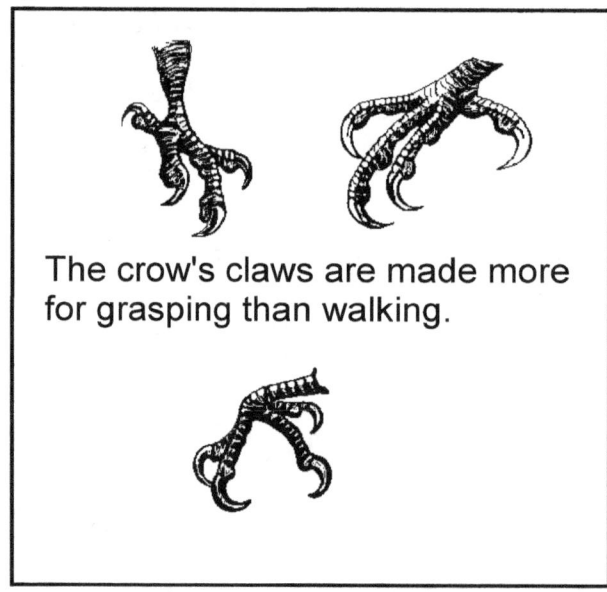

The crow's claws are made more for grasping than walking.

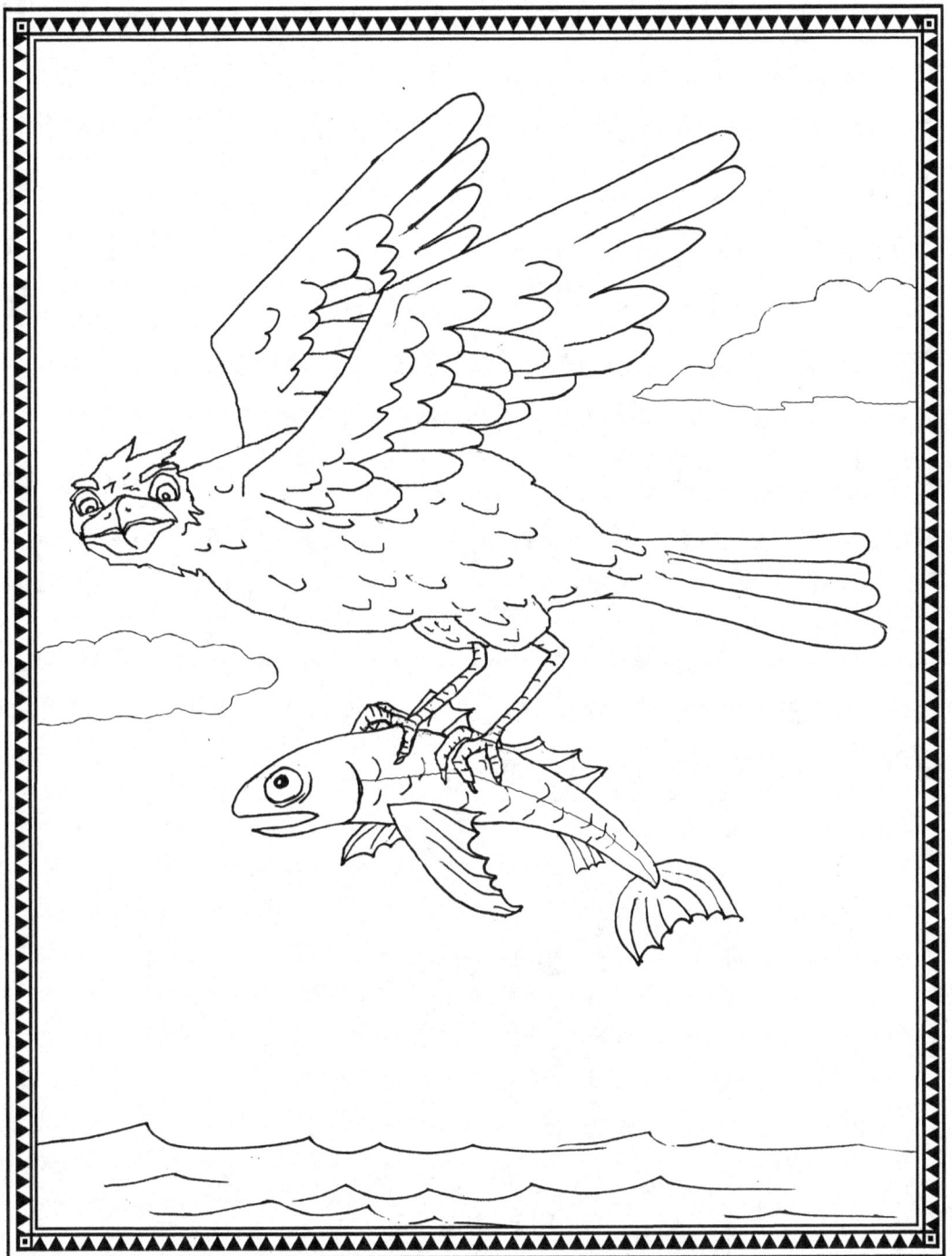

Kalani looked at the sea passing below. He thought of all the good times he had swimming with his family and friends in the waves below. The crow kept on flying, they were getting closer to the island. Kalani felt so sad, His past life was gone, never again would he swim in the sea, never again would he and his brothers and sisters skim across the waves together. He was so very sad. And then he began to cry. Big wet tears formed as he thought about the life with his friends beneath the sea. and as he cried, his tears flowed back across his body, and his skin became wet again.

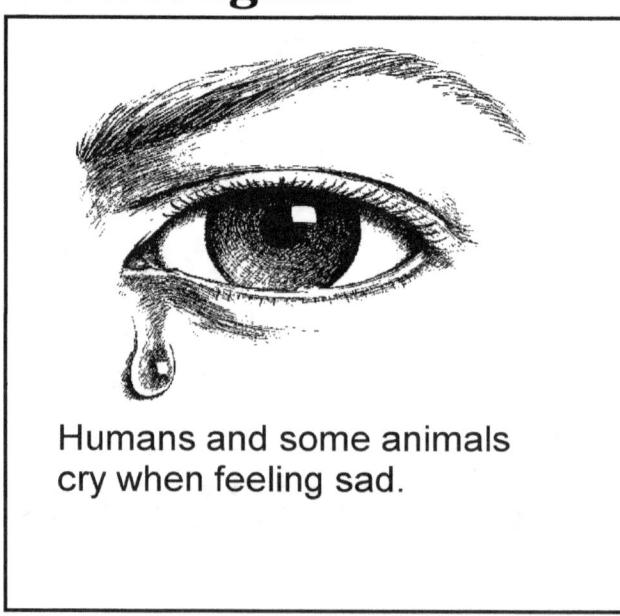

Humans and some animals cry when feeling sad.

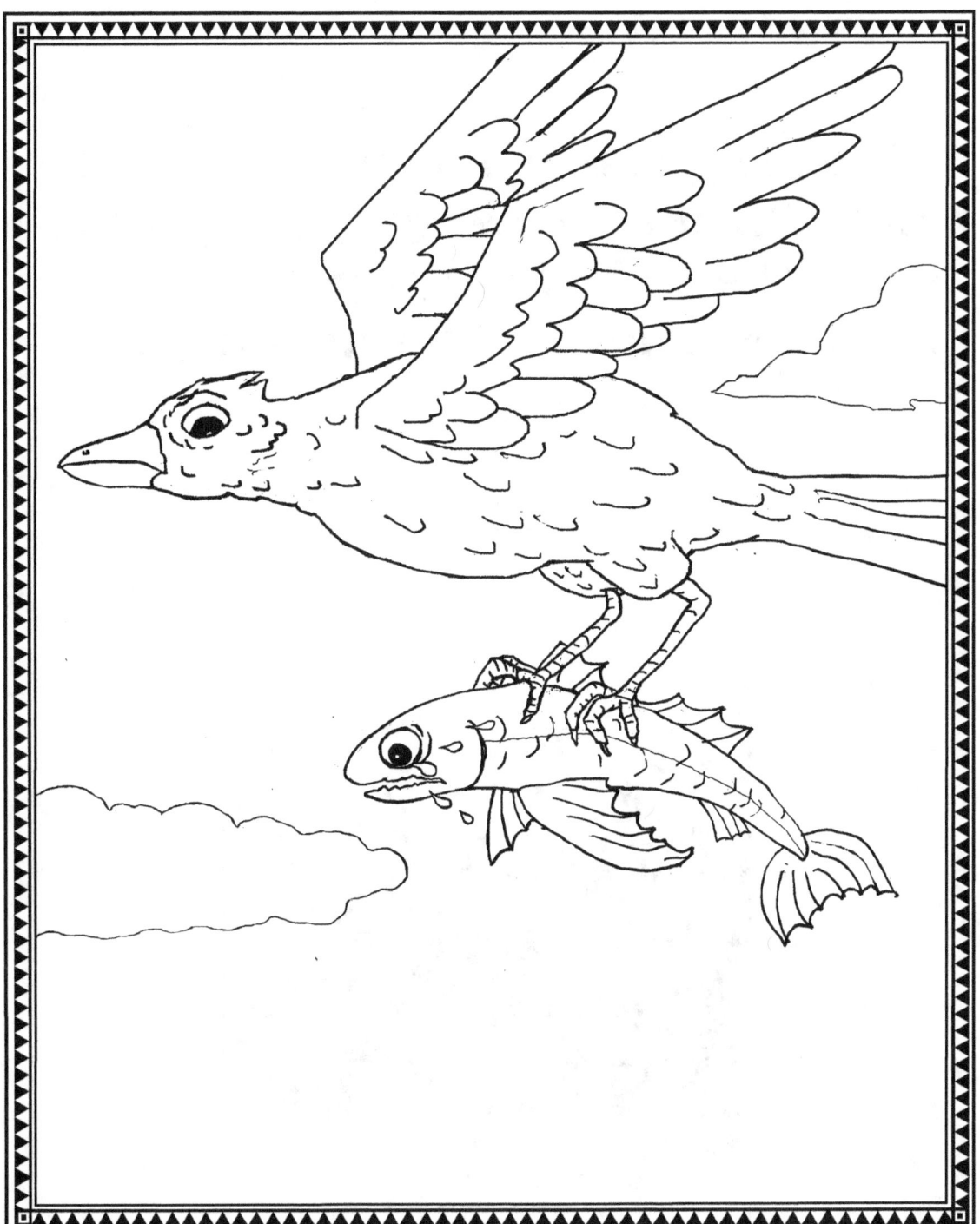

His scales glistened with the moisture and with one final wiggle, he squirted out of the bird's tight grip, and with head down he dived towards the sea.

Fish scales require mosture to develop a coat of slime.

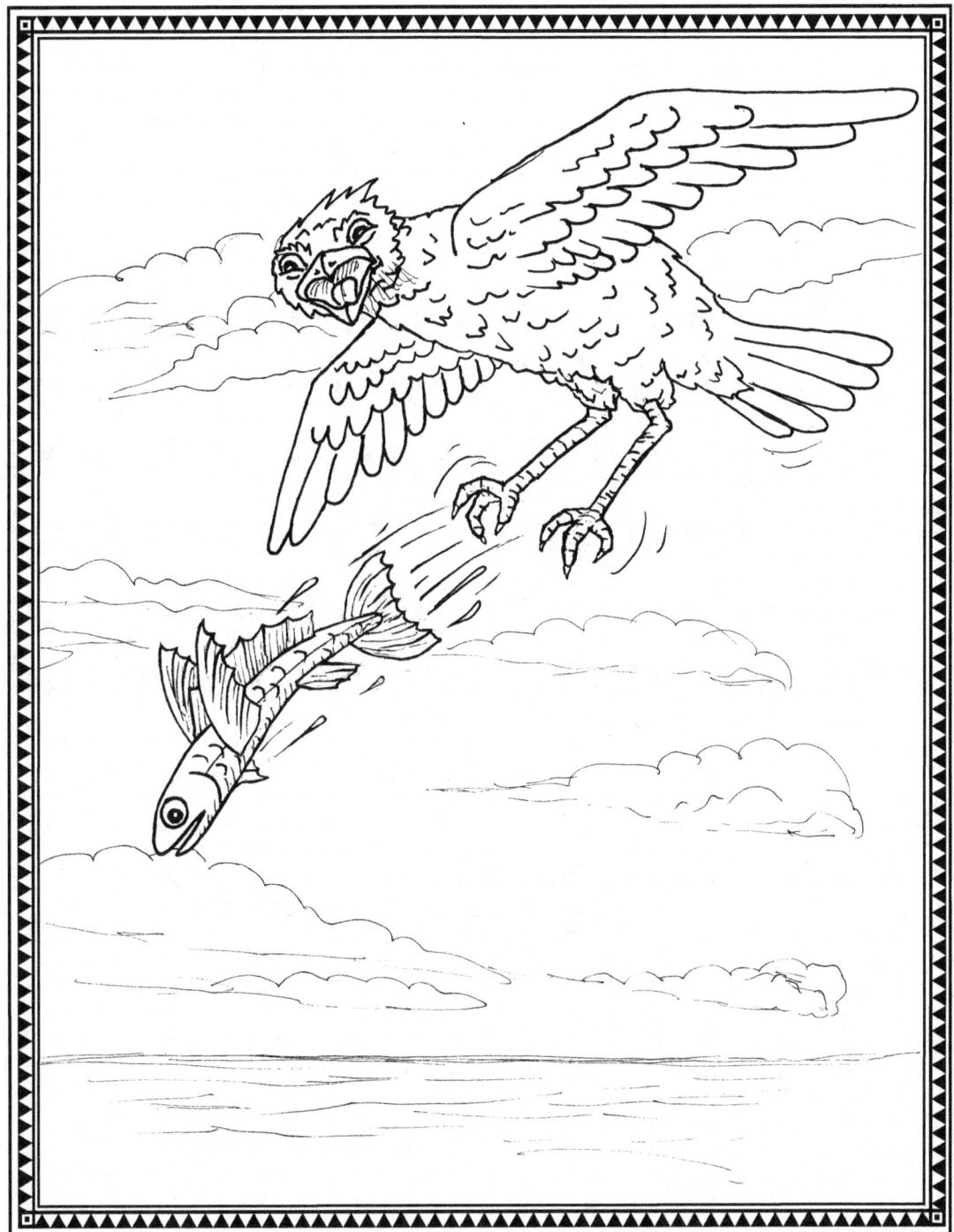

The black crow tried to catch up with him but Kalani tucked in his wings and shot straight down into the the cool waves below. With a splash, Kalani plunged deep into the ocean. He was home again!

Laminar air flow around an aerodynamic shape with no drag.

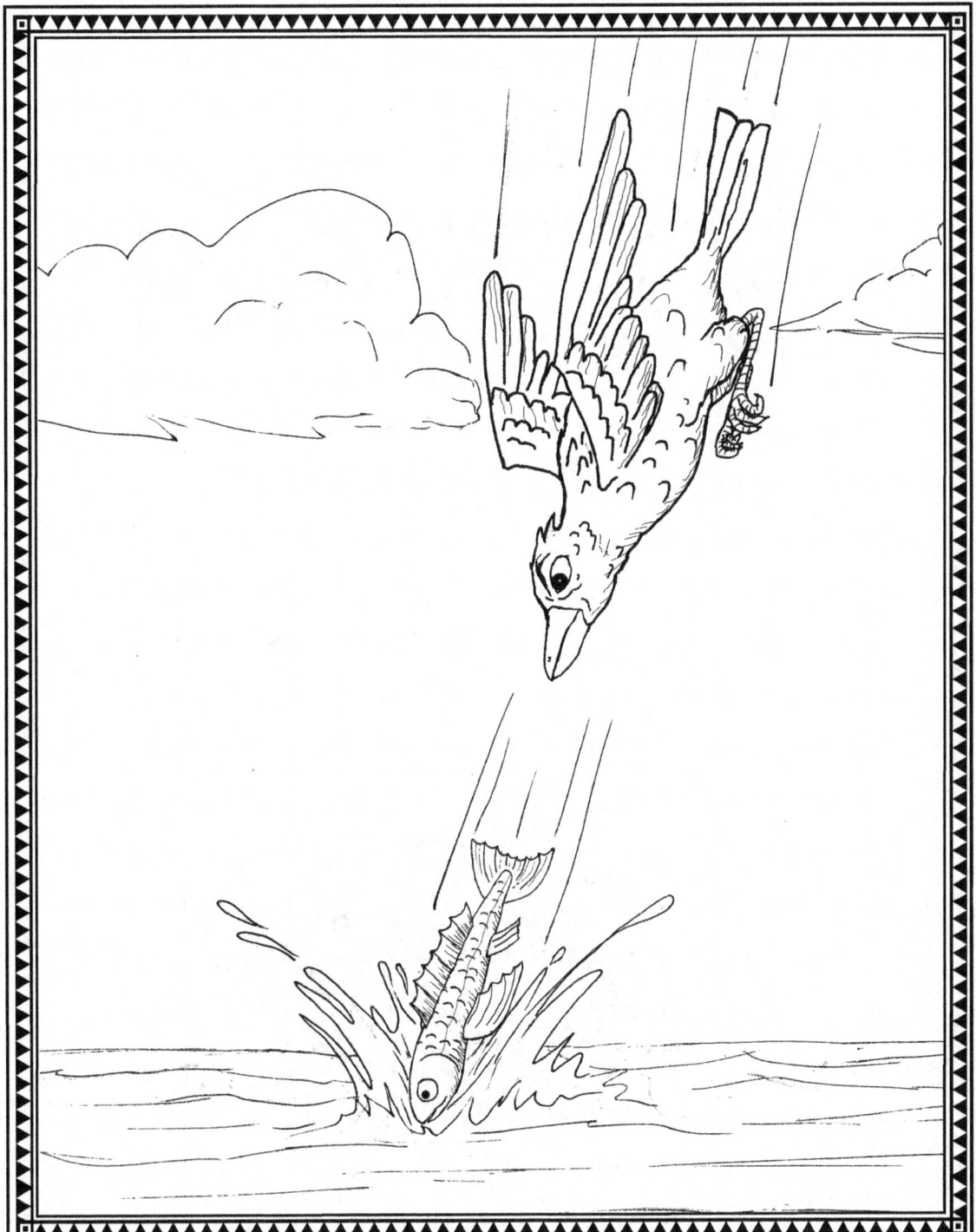

The bird had to fly off alone, mad that he had lost his supper. But Kalani was glad.

Thinking of a fish dinner.

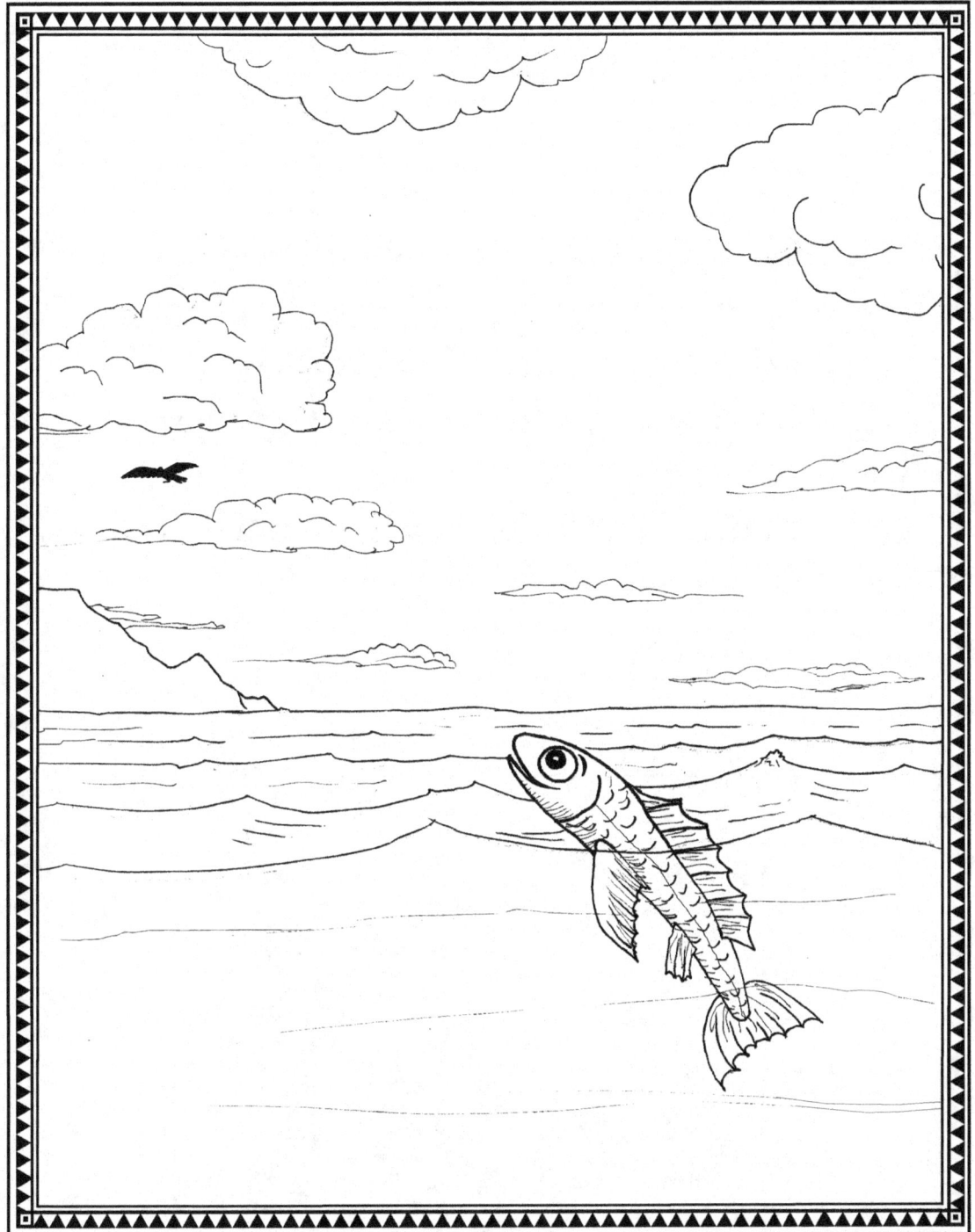

He was glad to be back where he belonged. Soon he joined back up with his family and friends and they had so much fun swimming beneath the waves and occasionally popping out and skimming over the waves.

Tropical reef fish.

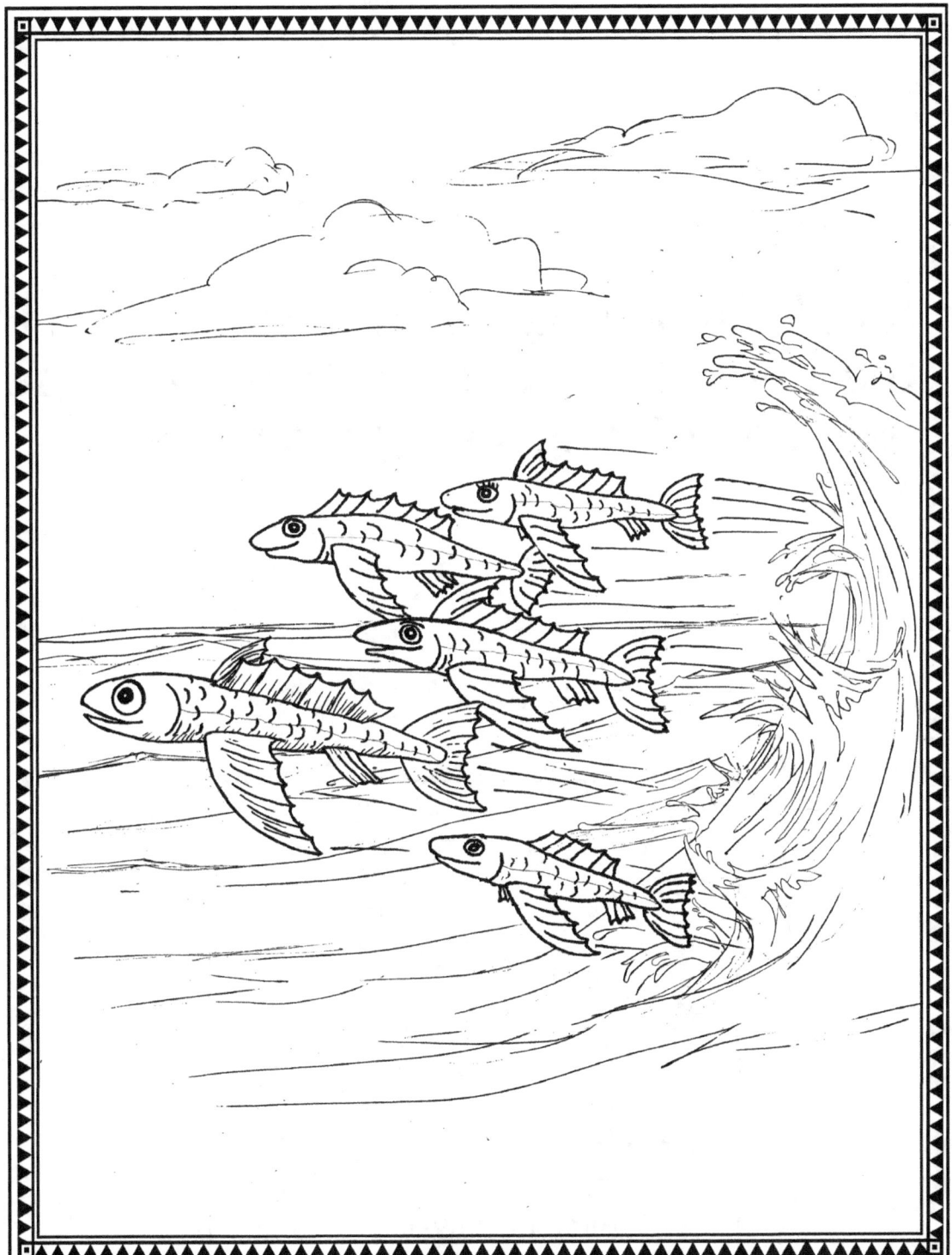

And he never again tried to fly high in the sky. And to this day. you never see flying fish flying so high in the sky.

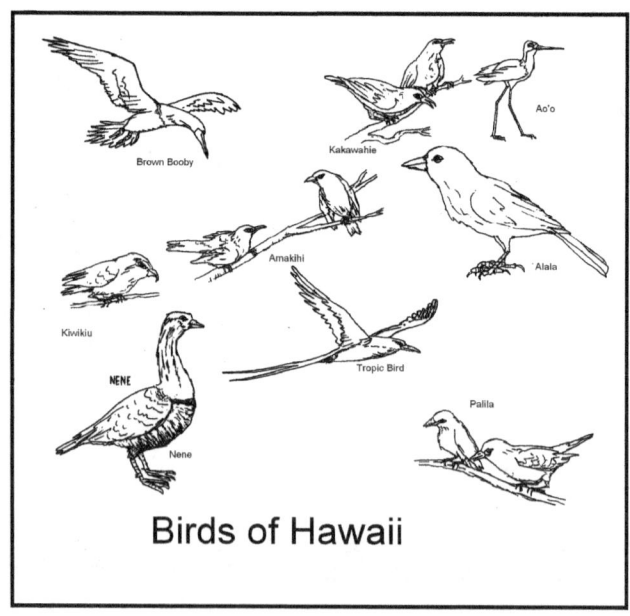

Birds of Hawaii

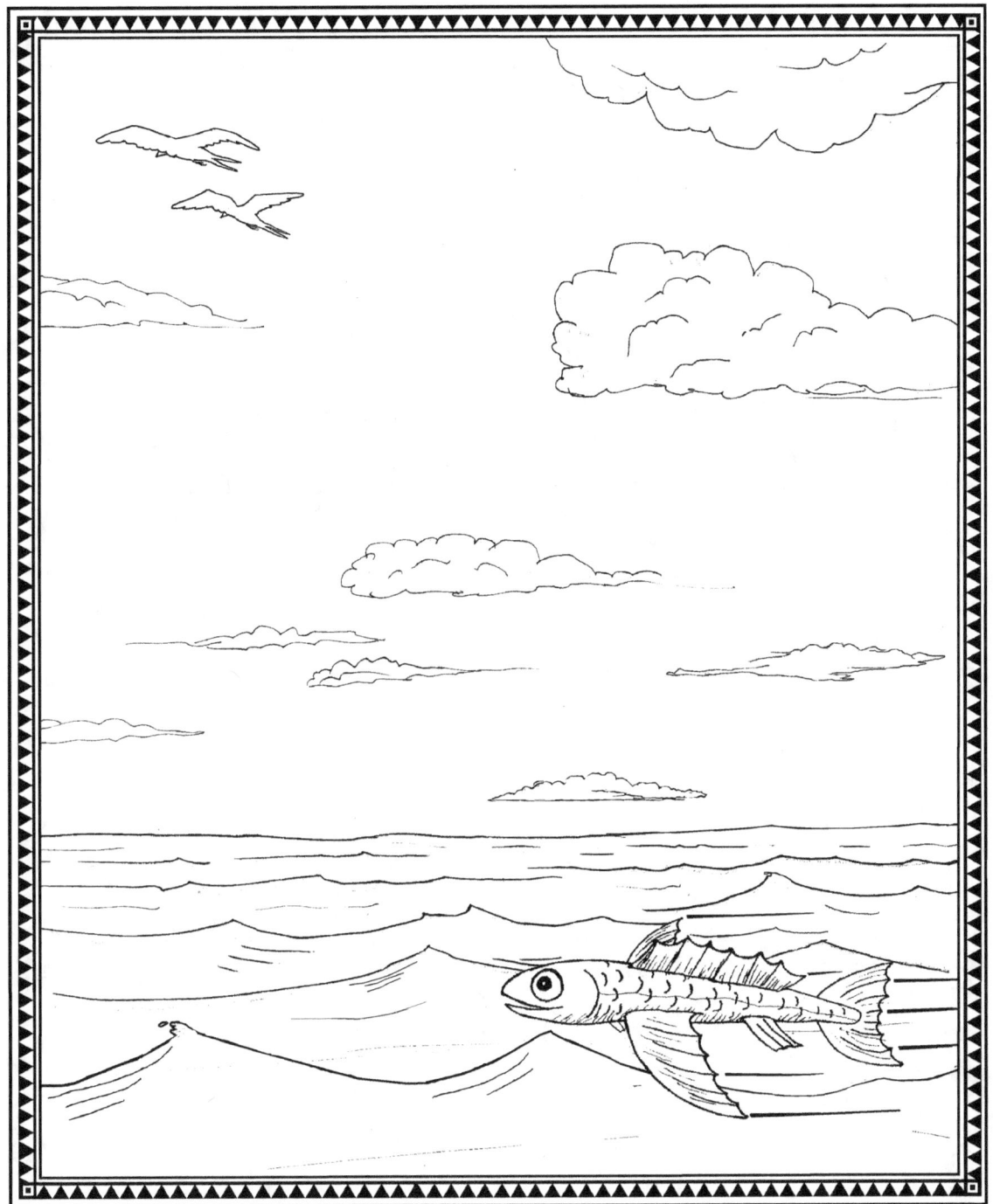

THE END

www.ingramcontent.com/pod-product-compliance
Lightning Source LLC
Chambersburg PA
CBHW060008230526
45472CB00008B/1997